Whimsical Wilds

Coloring & Story Book

Illustrations by:
Amy Jacomet

Stories Written and
Illustrations Colored by:

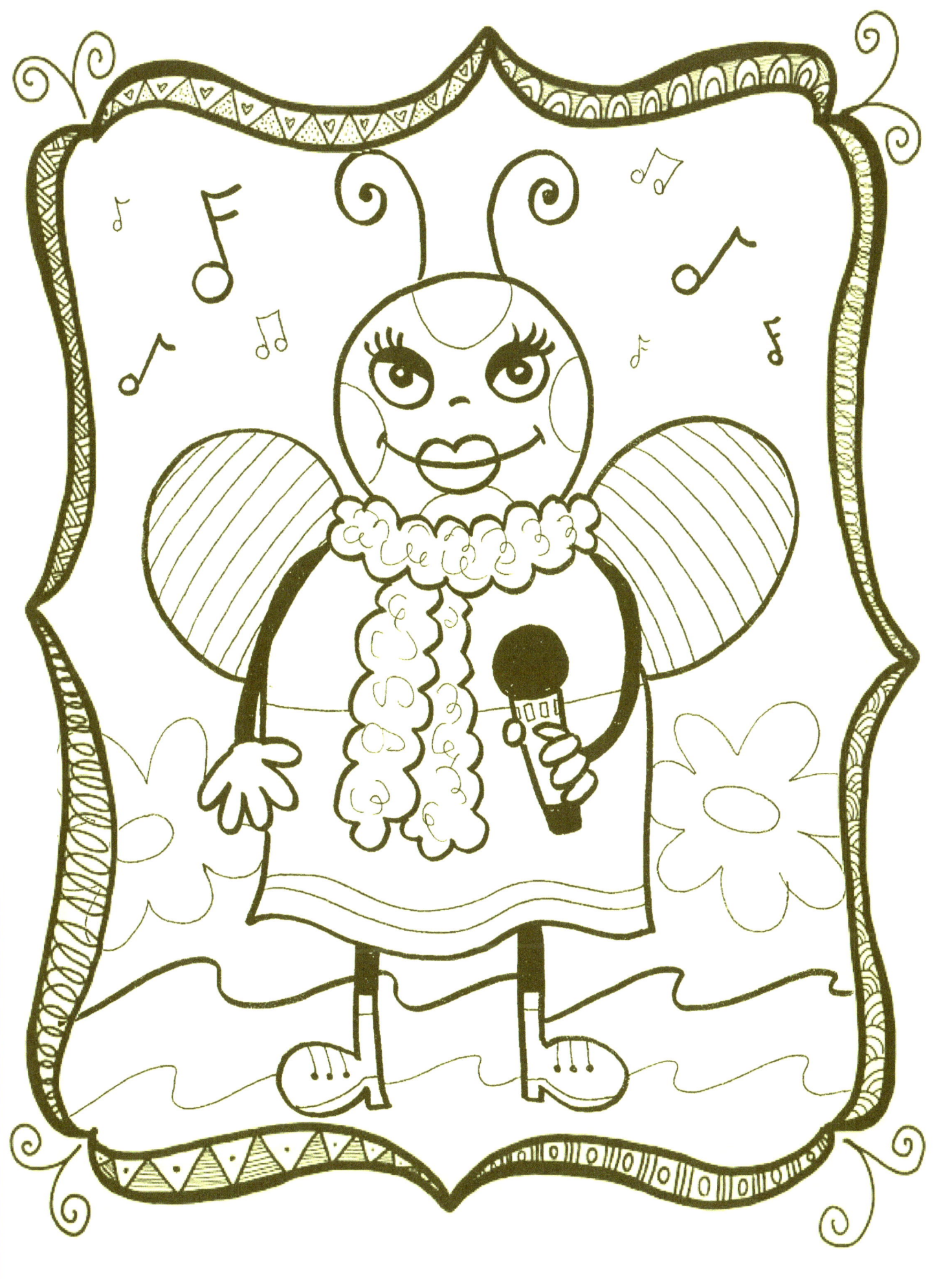

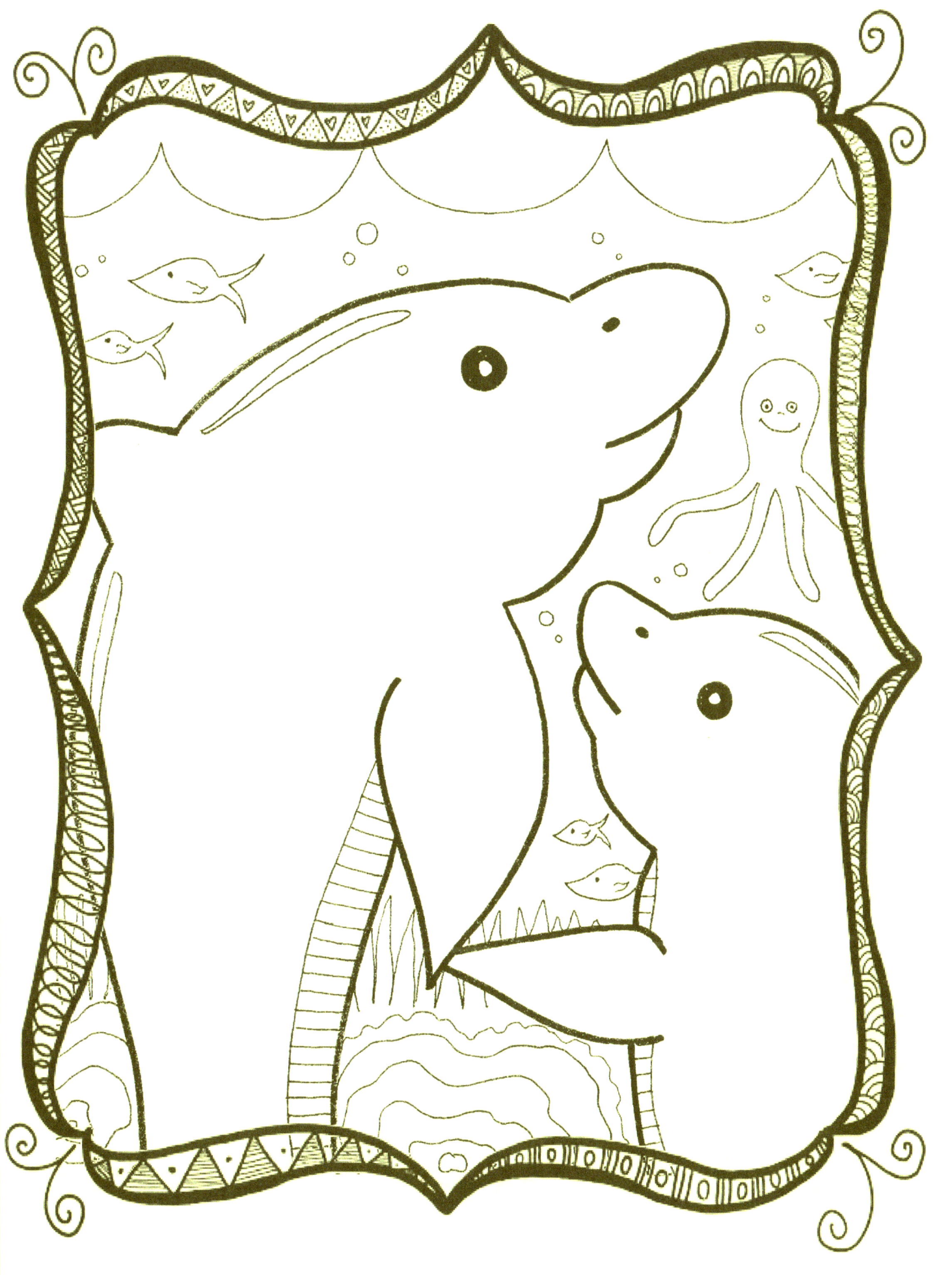

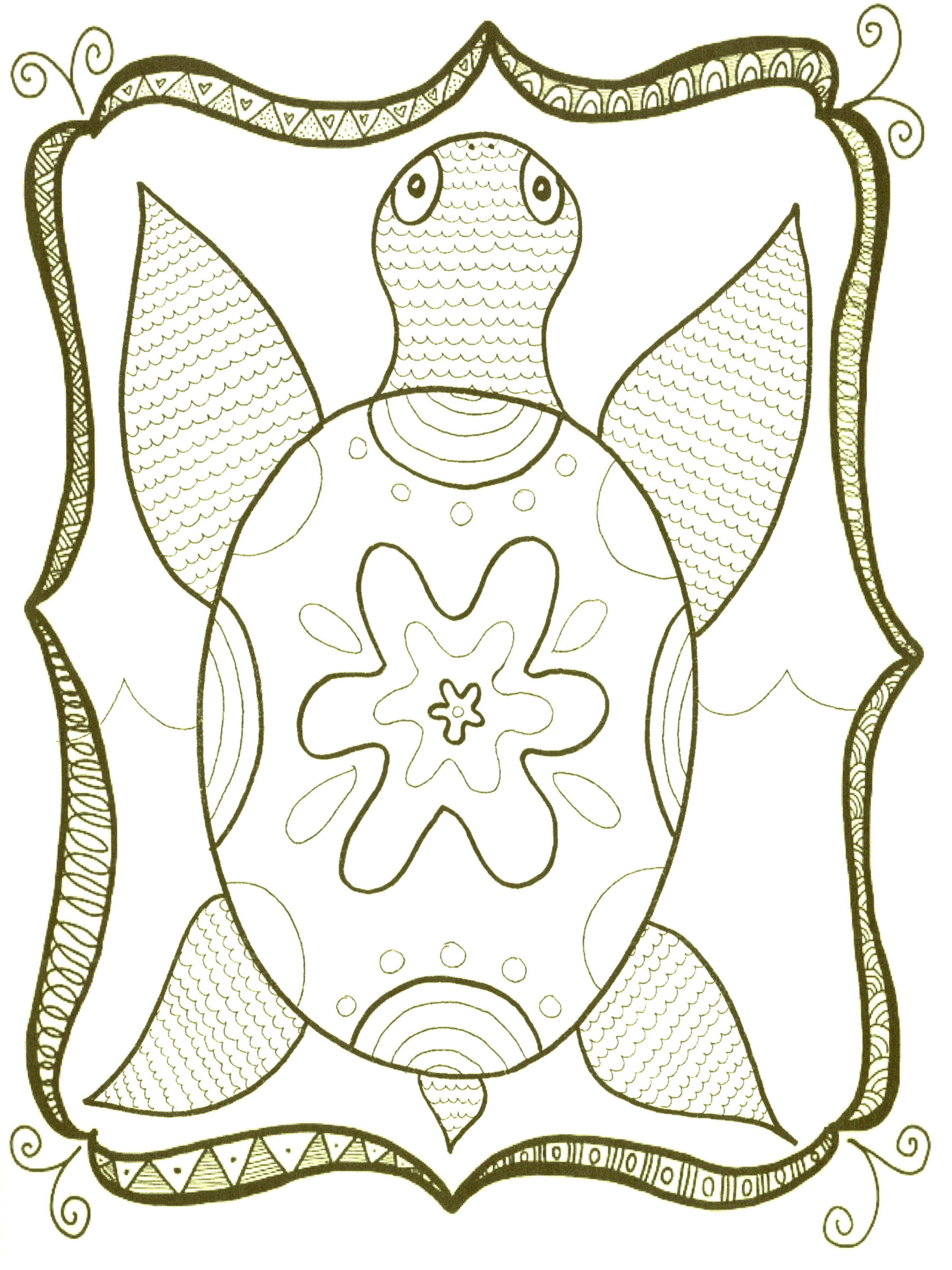

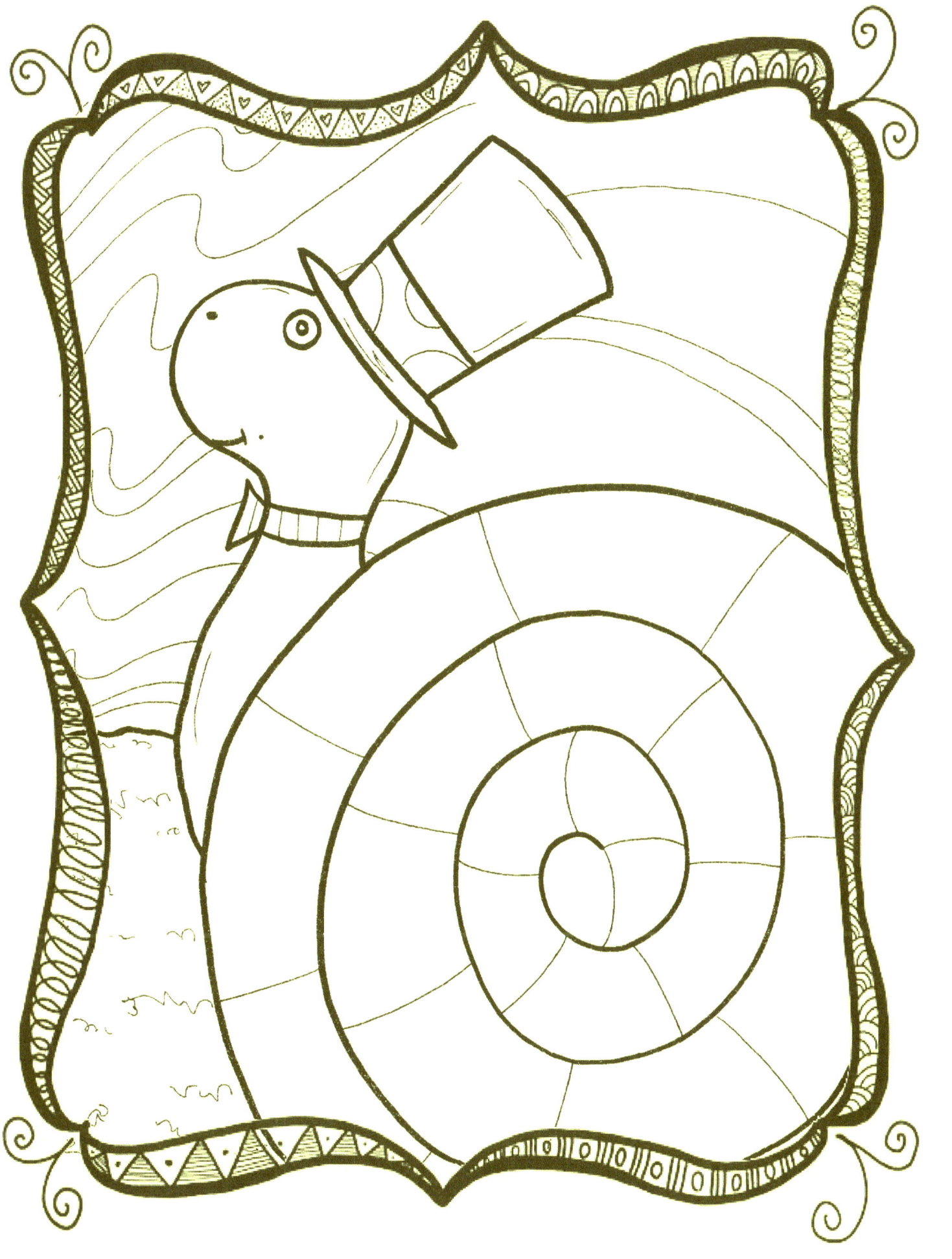

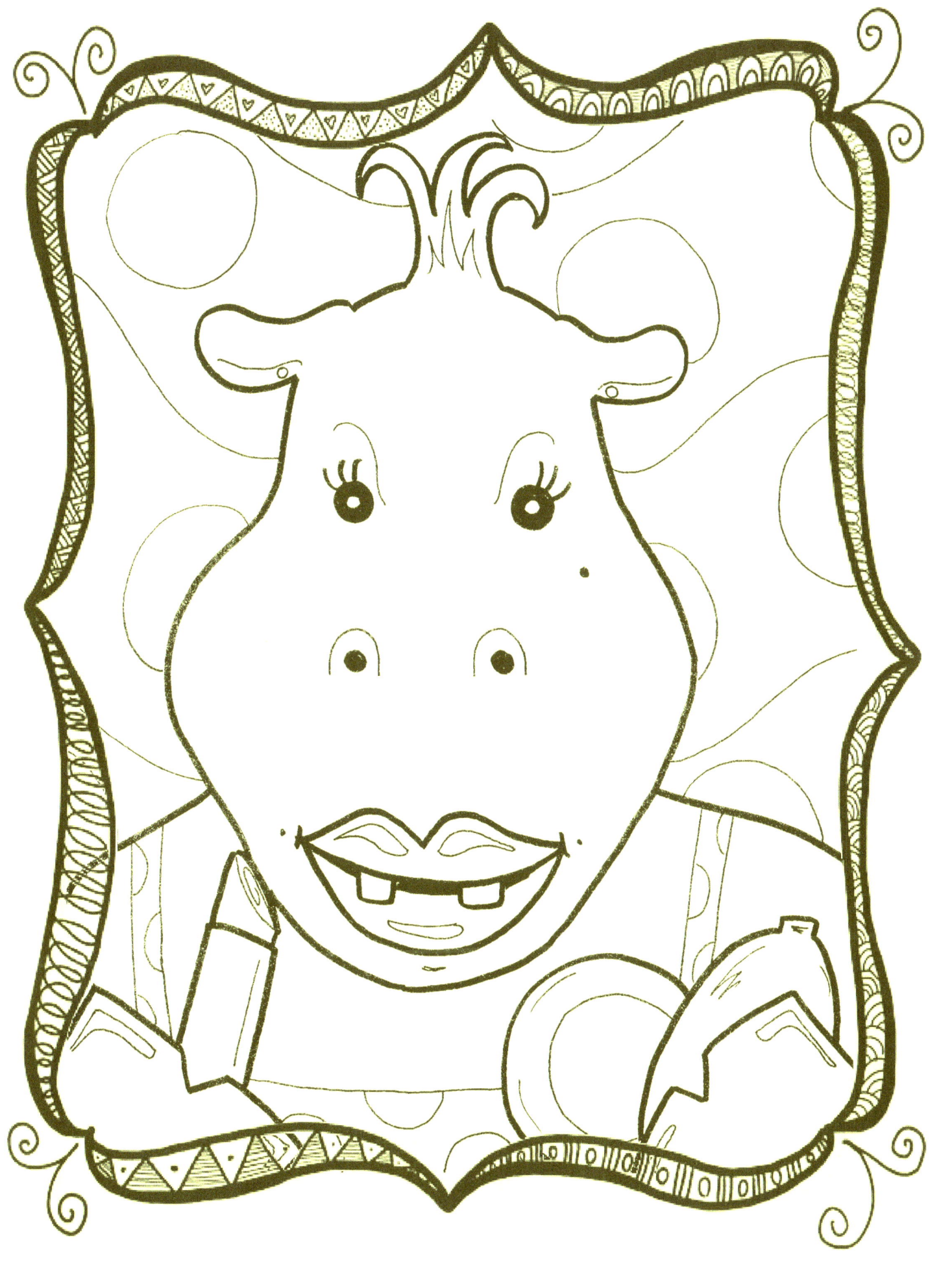

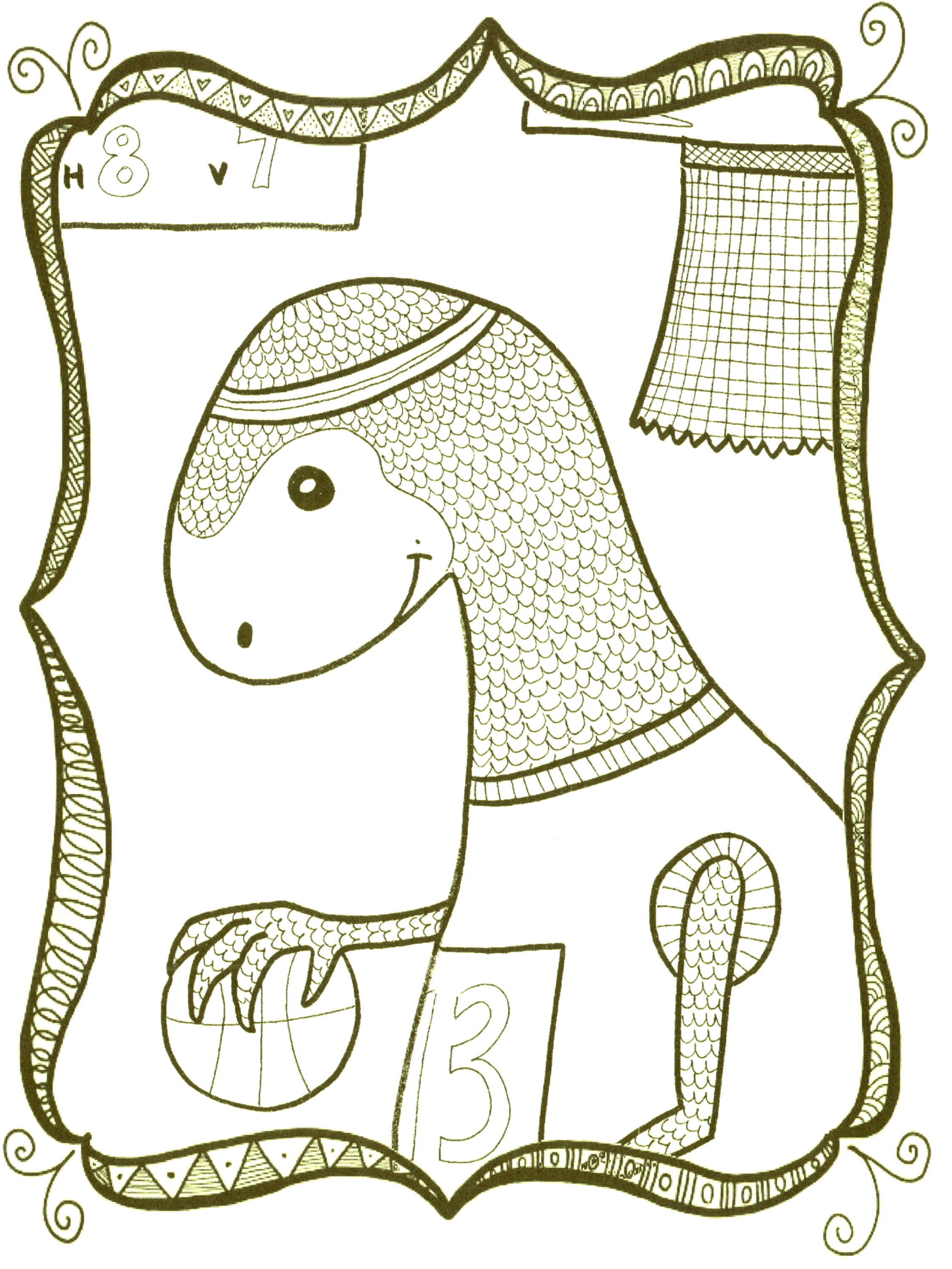

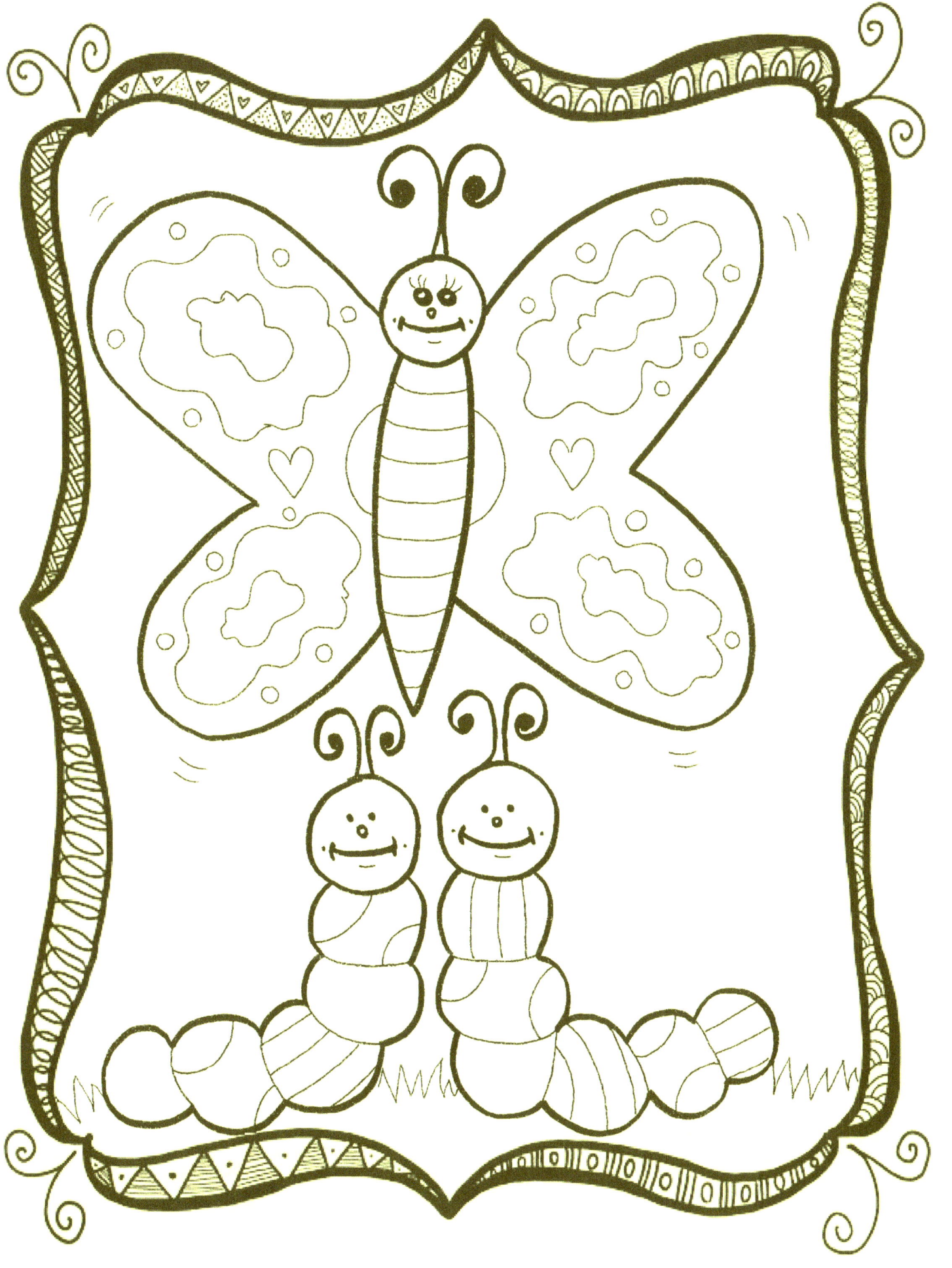

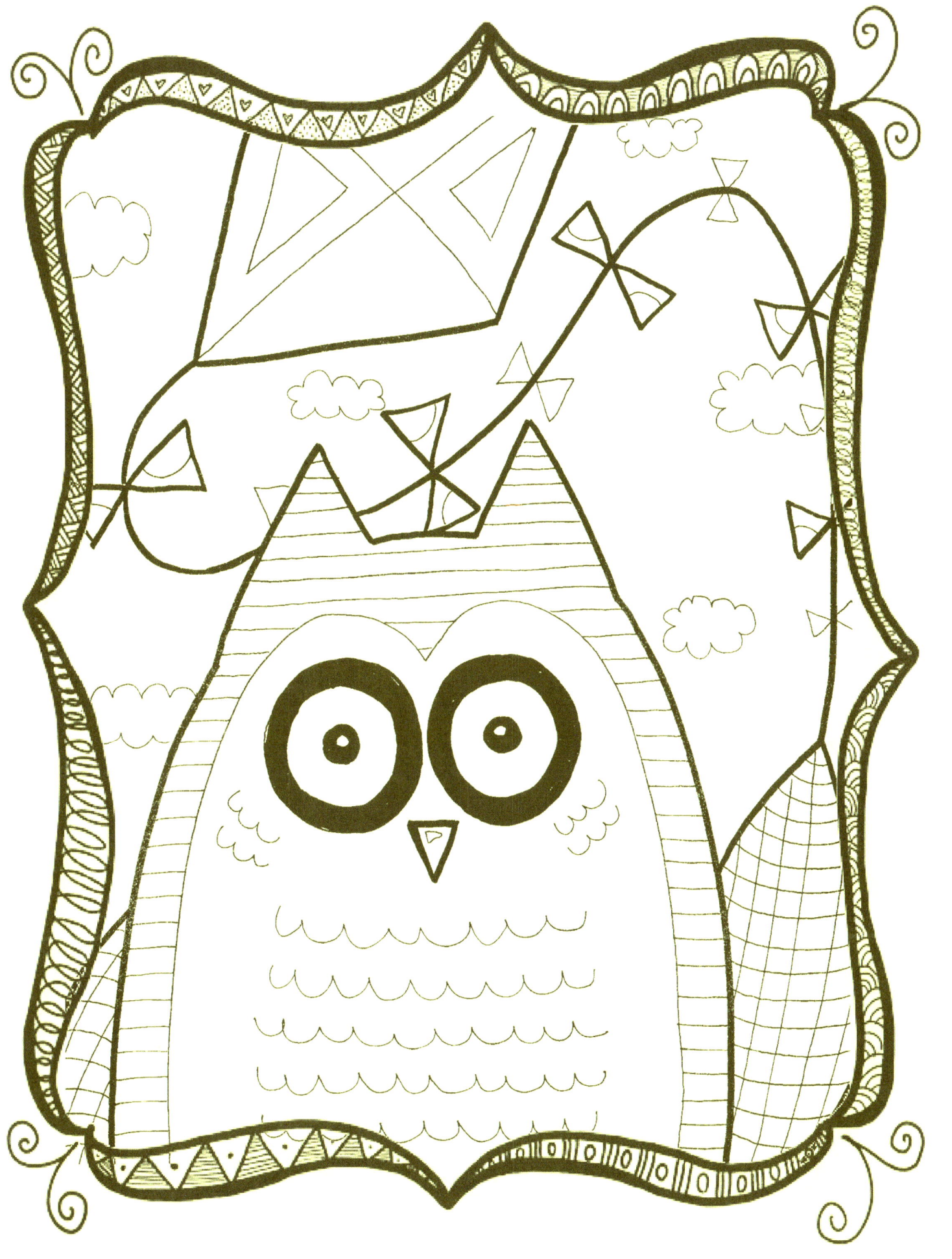

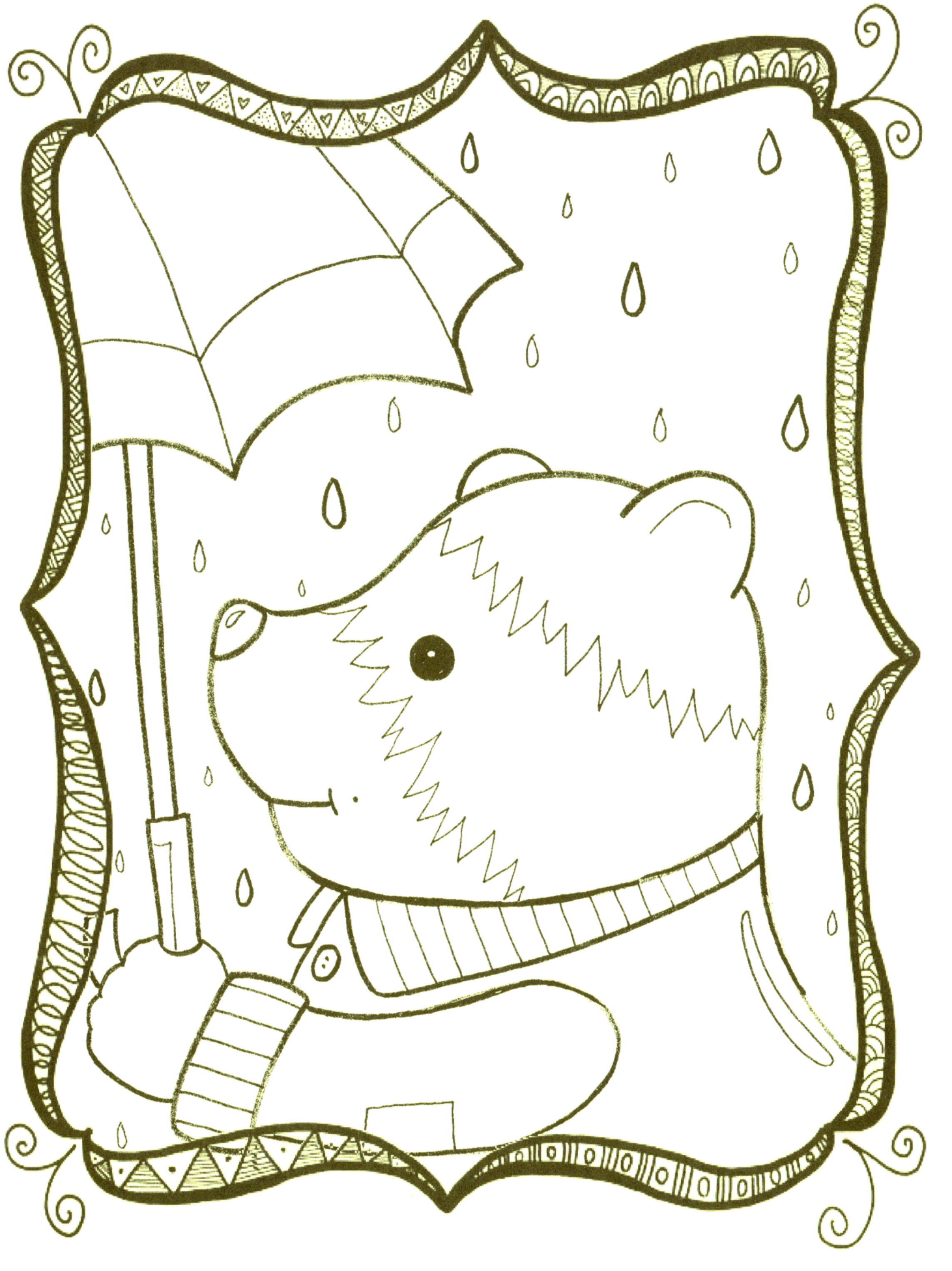

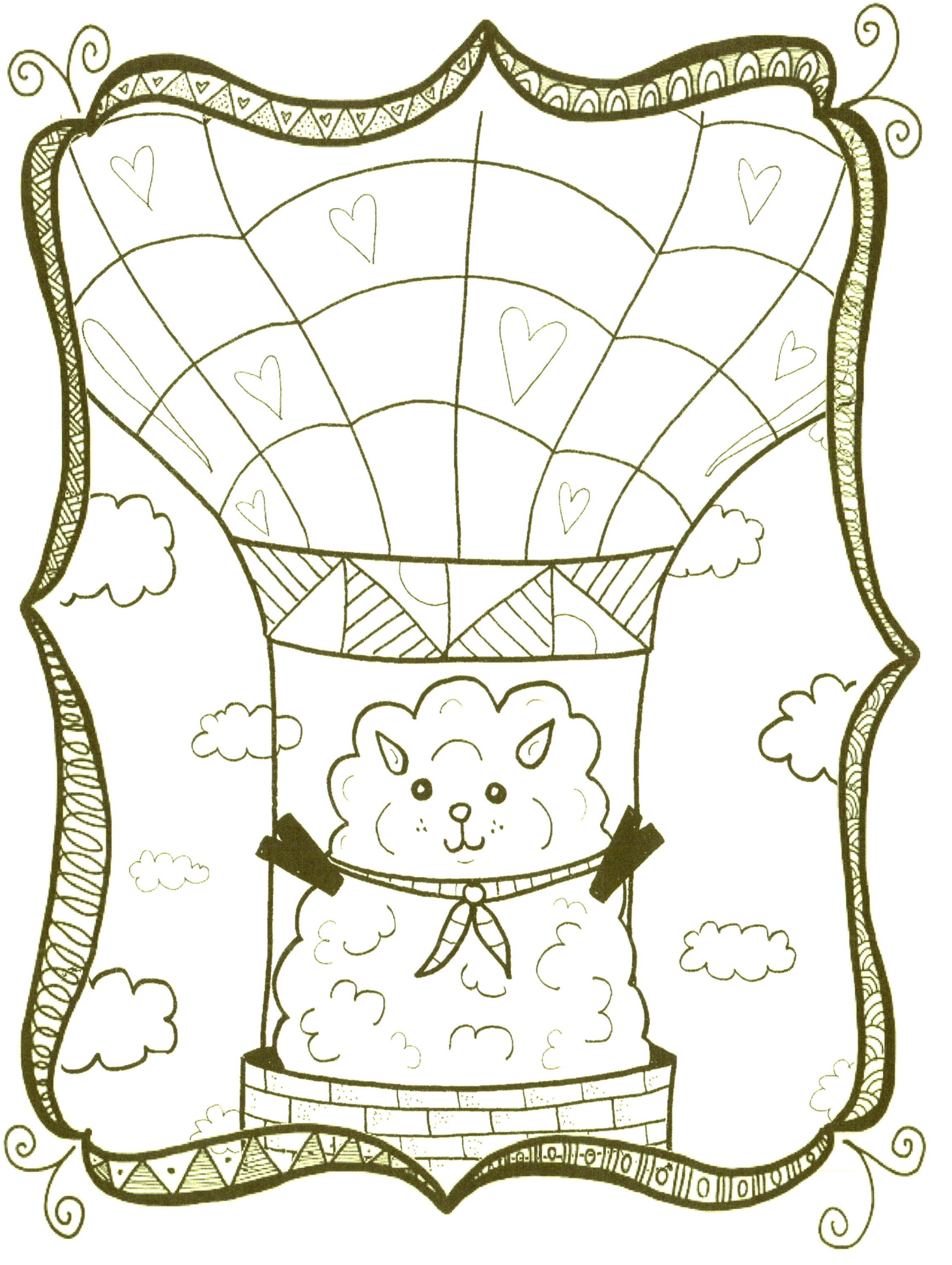

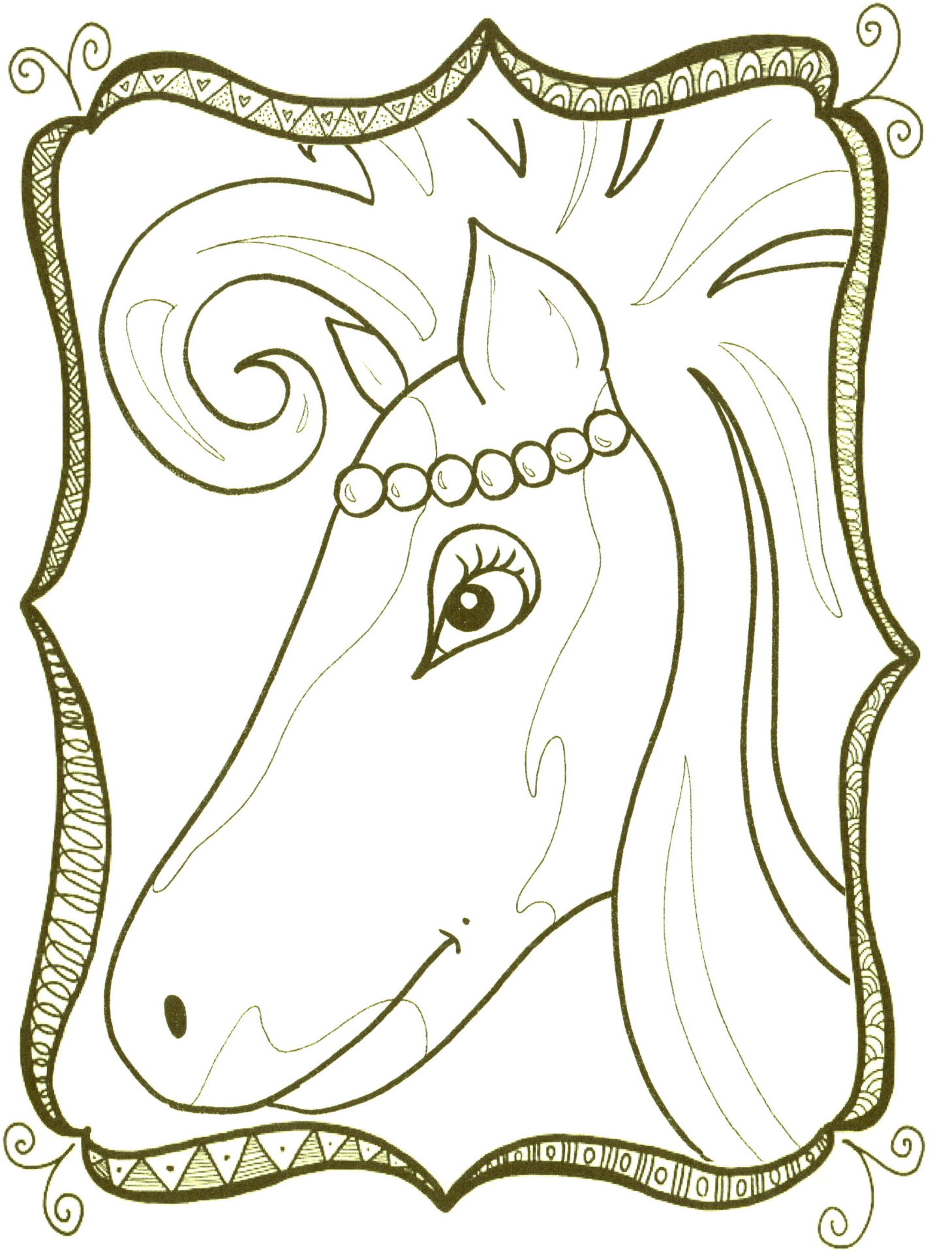

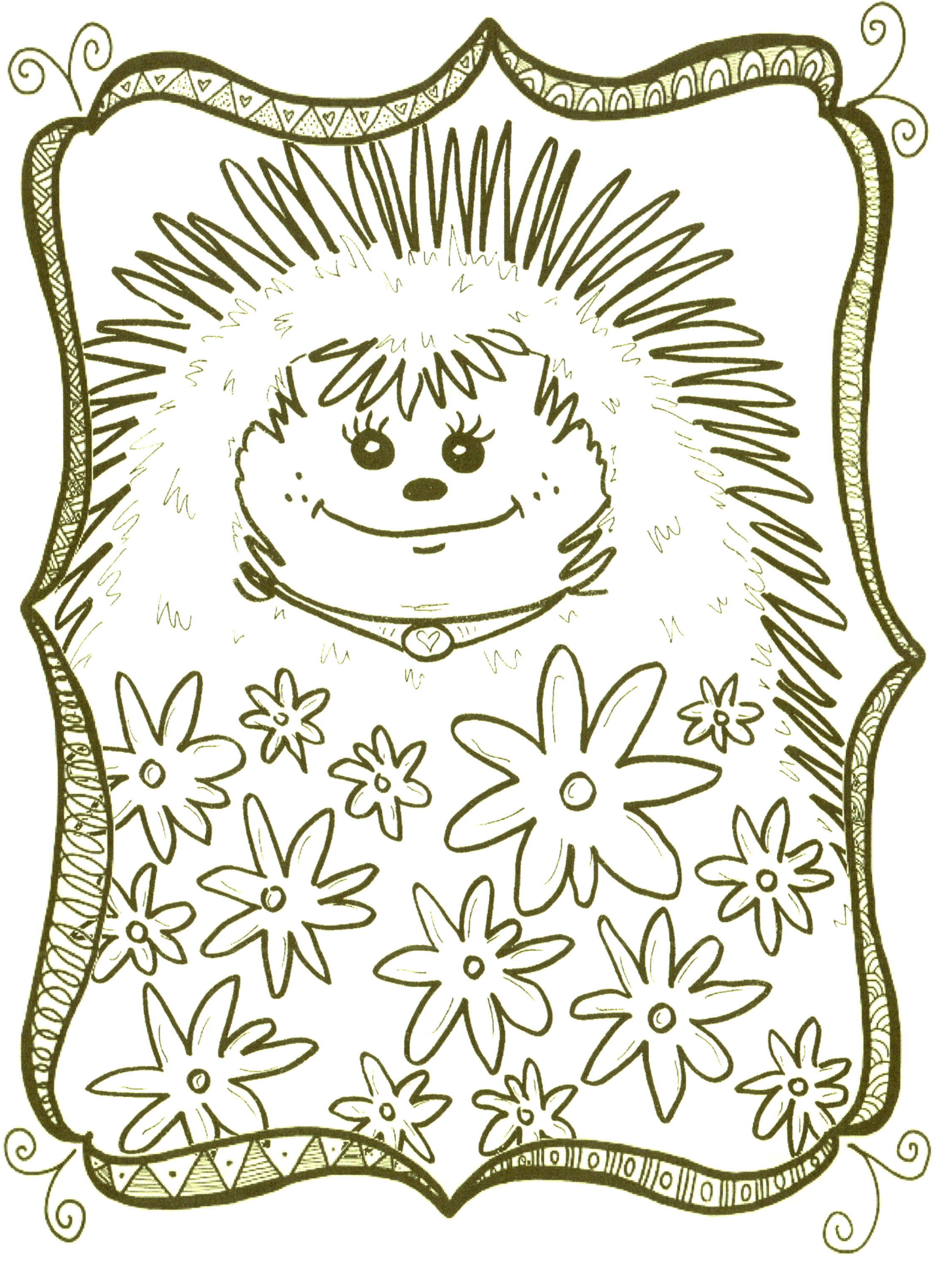

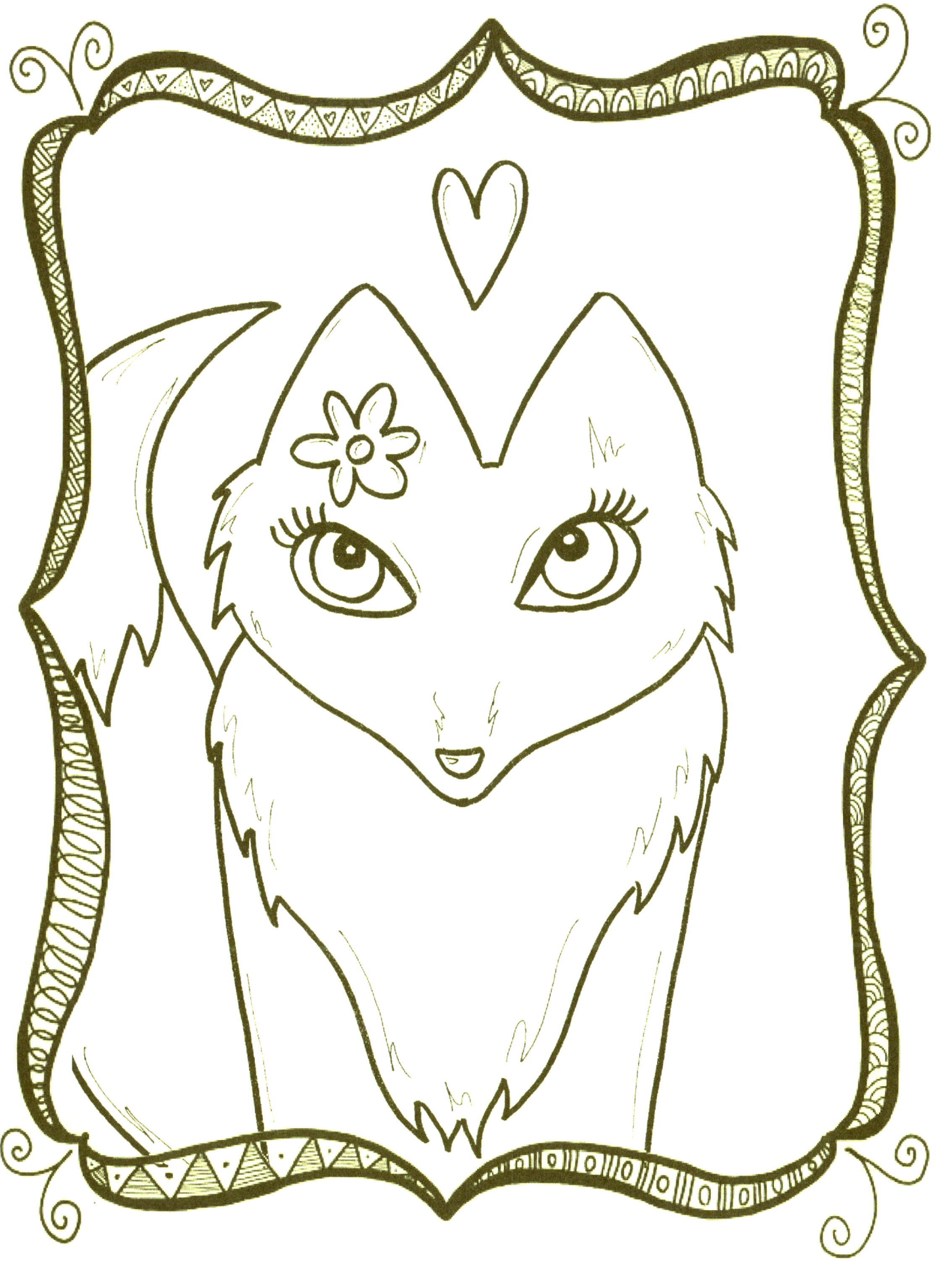

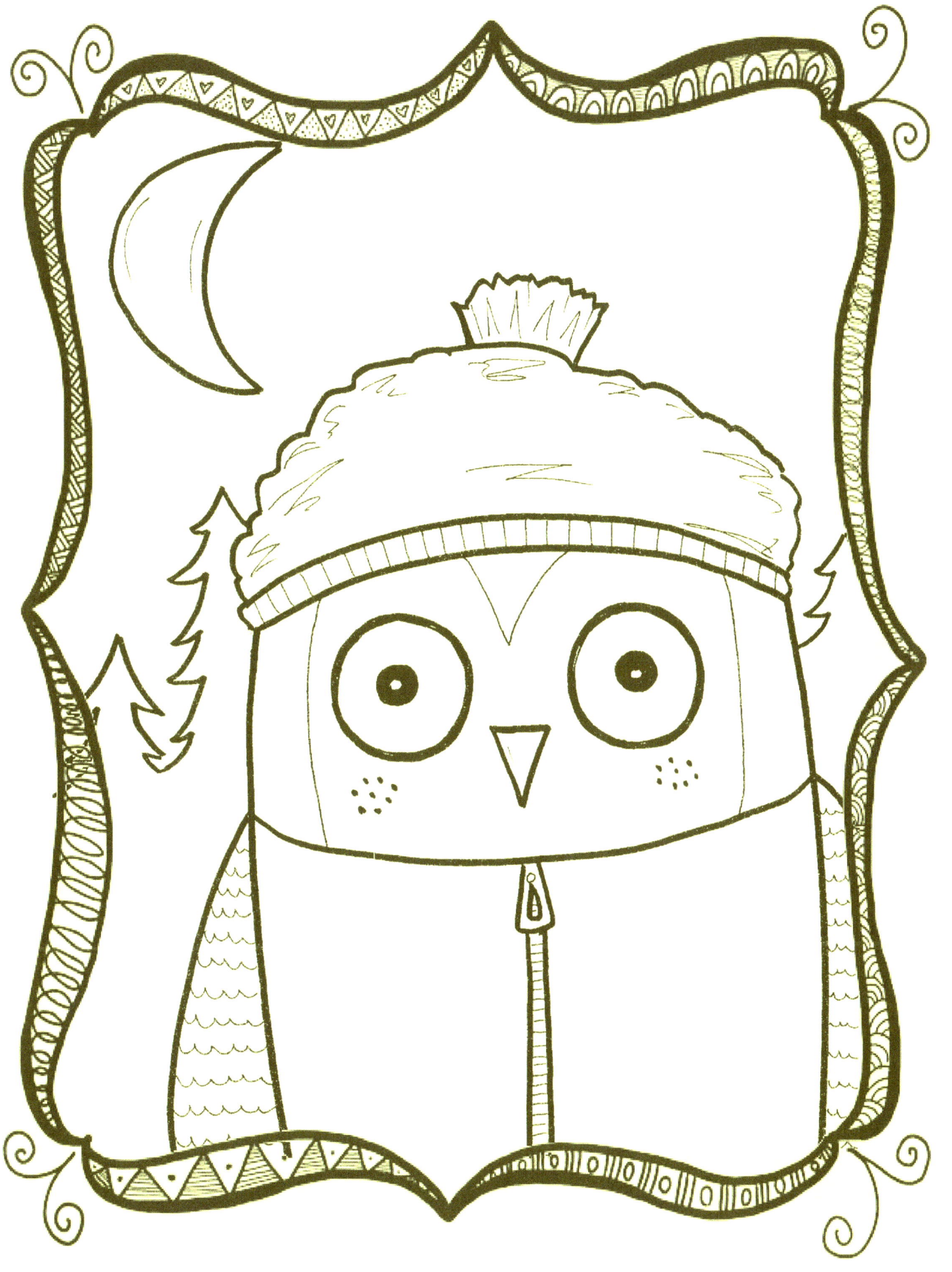

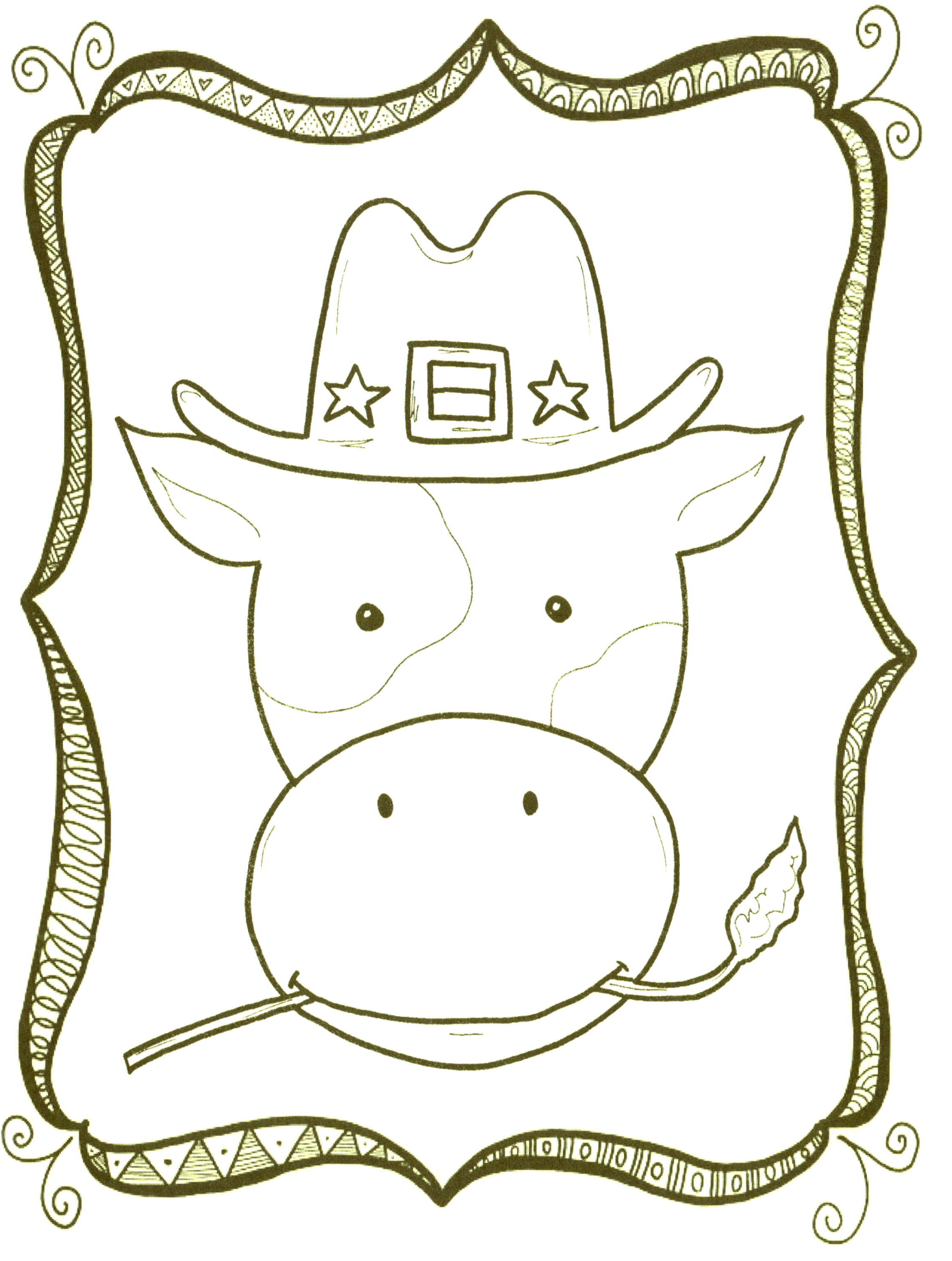

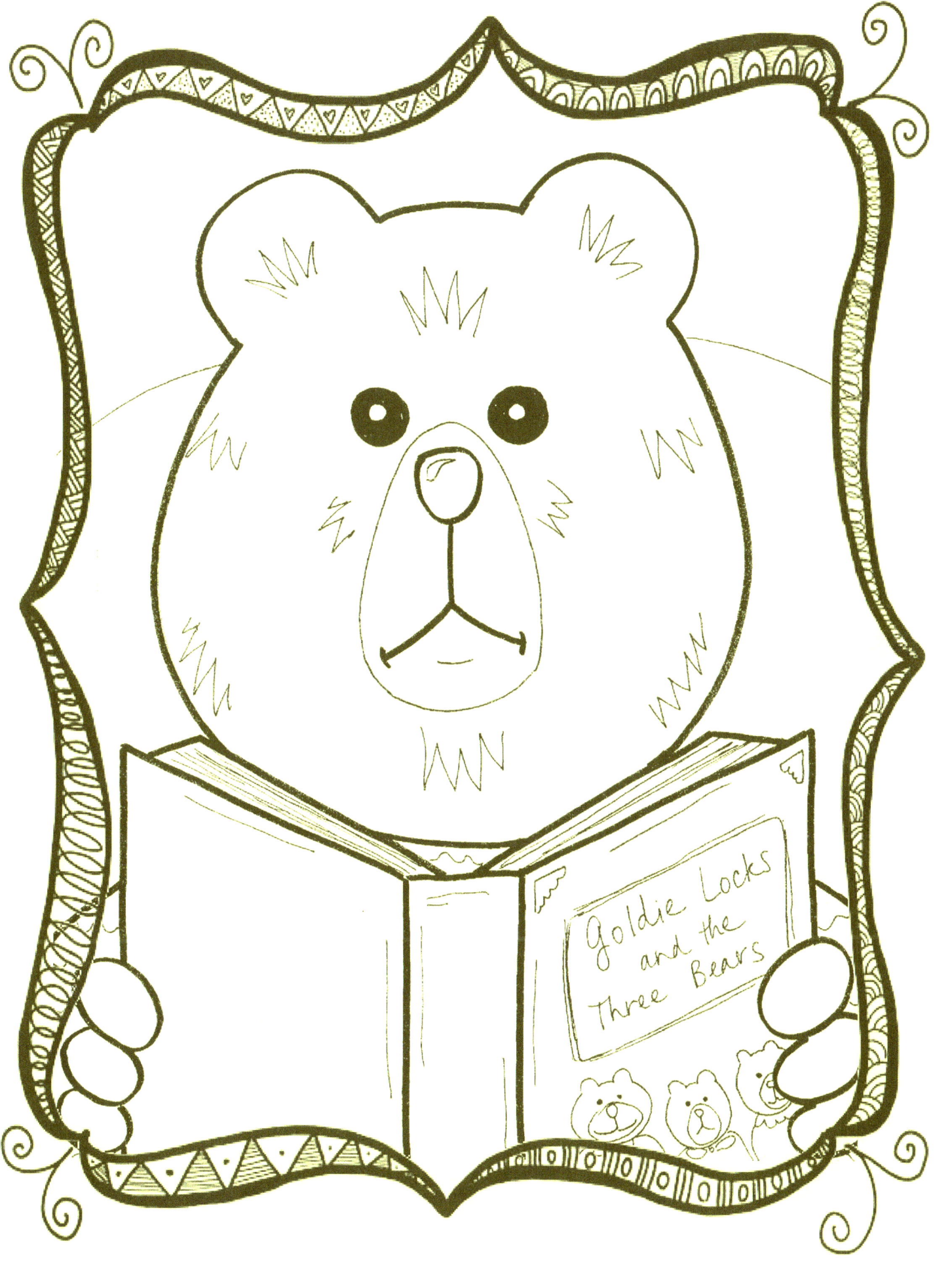

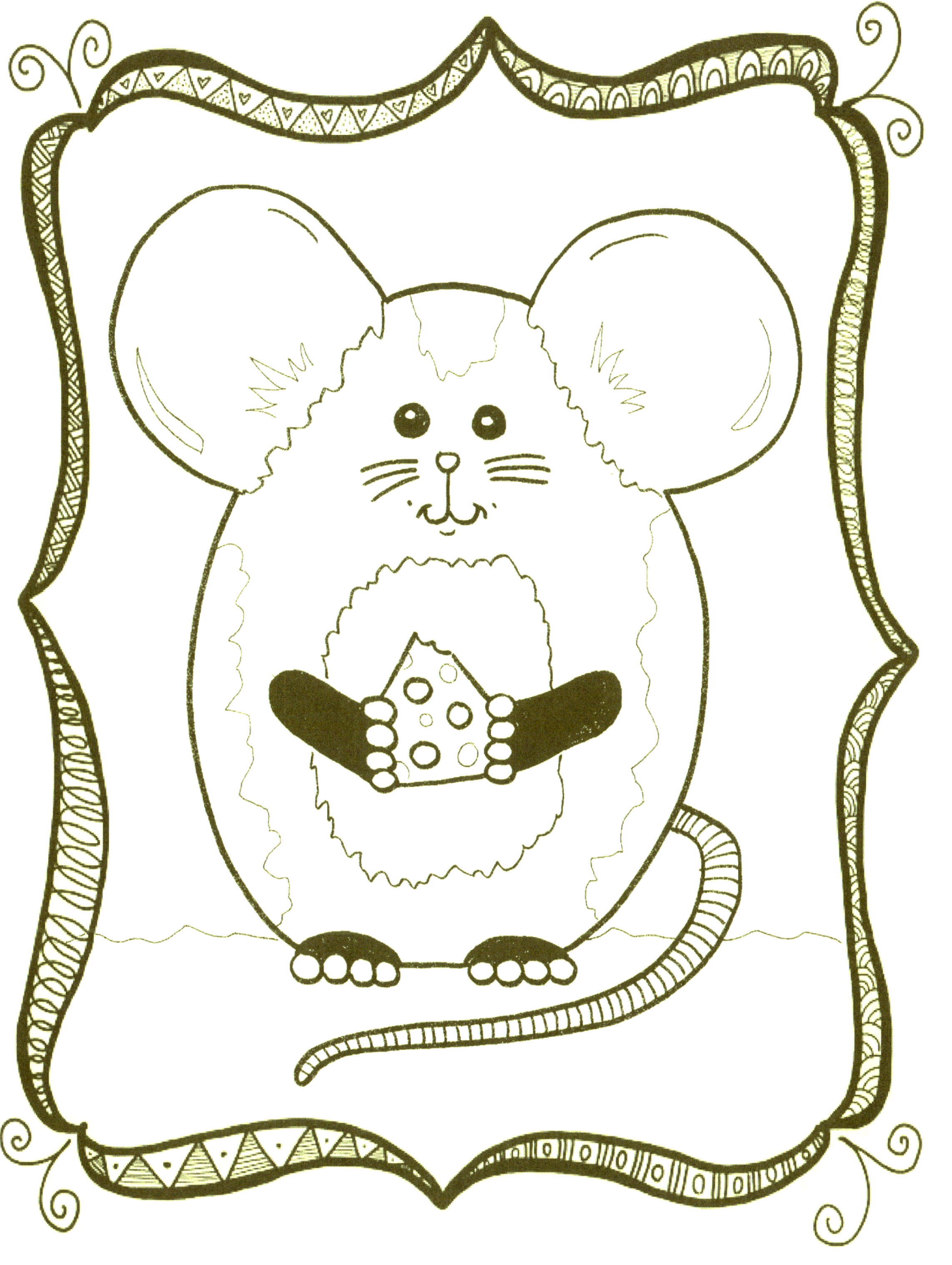

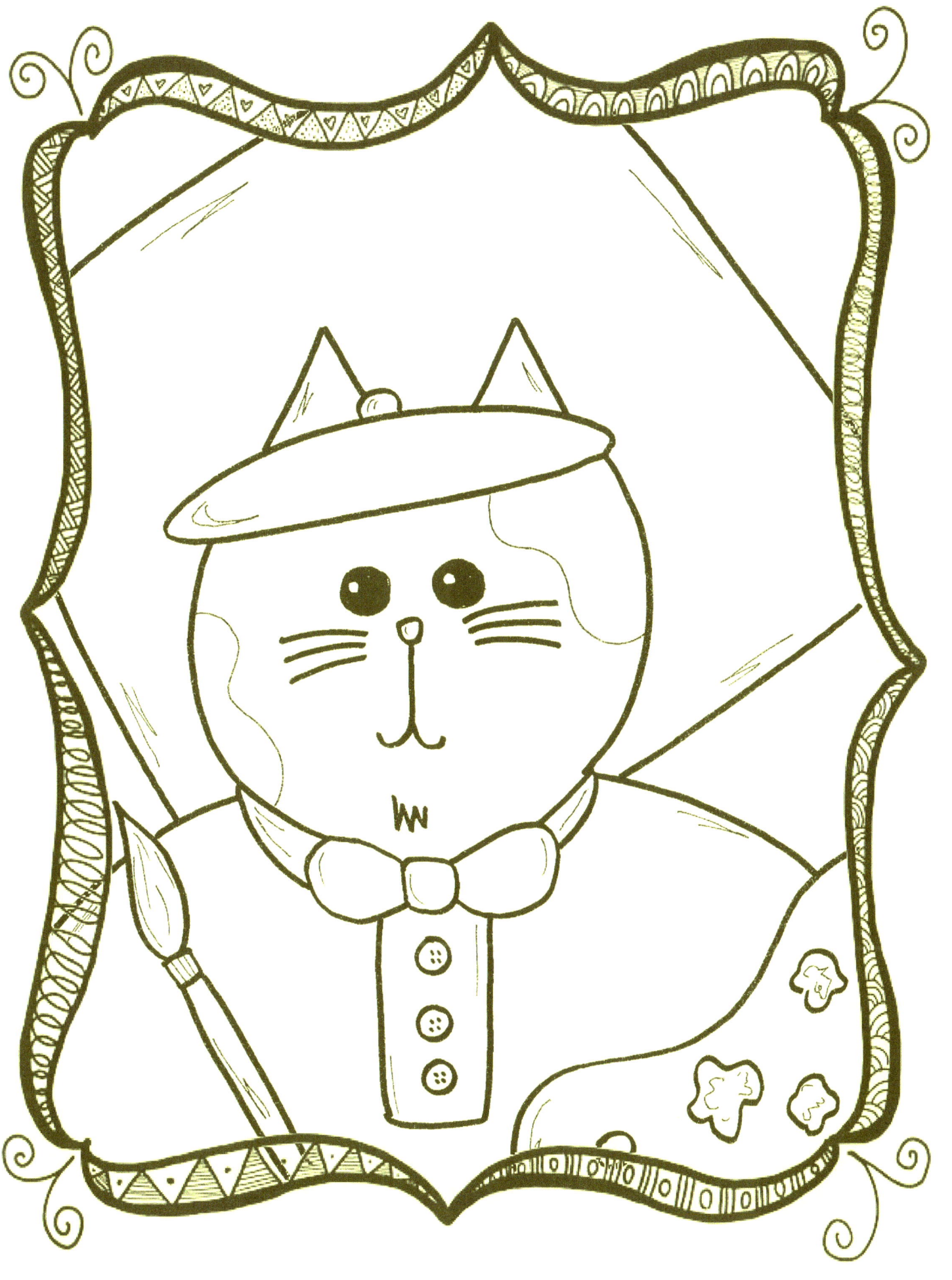

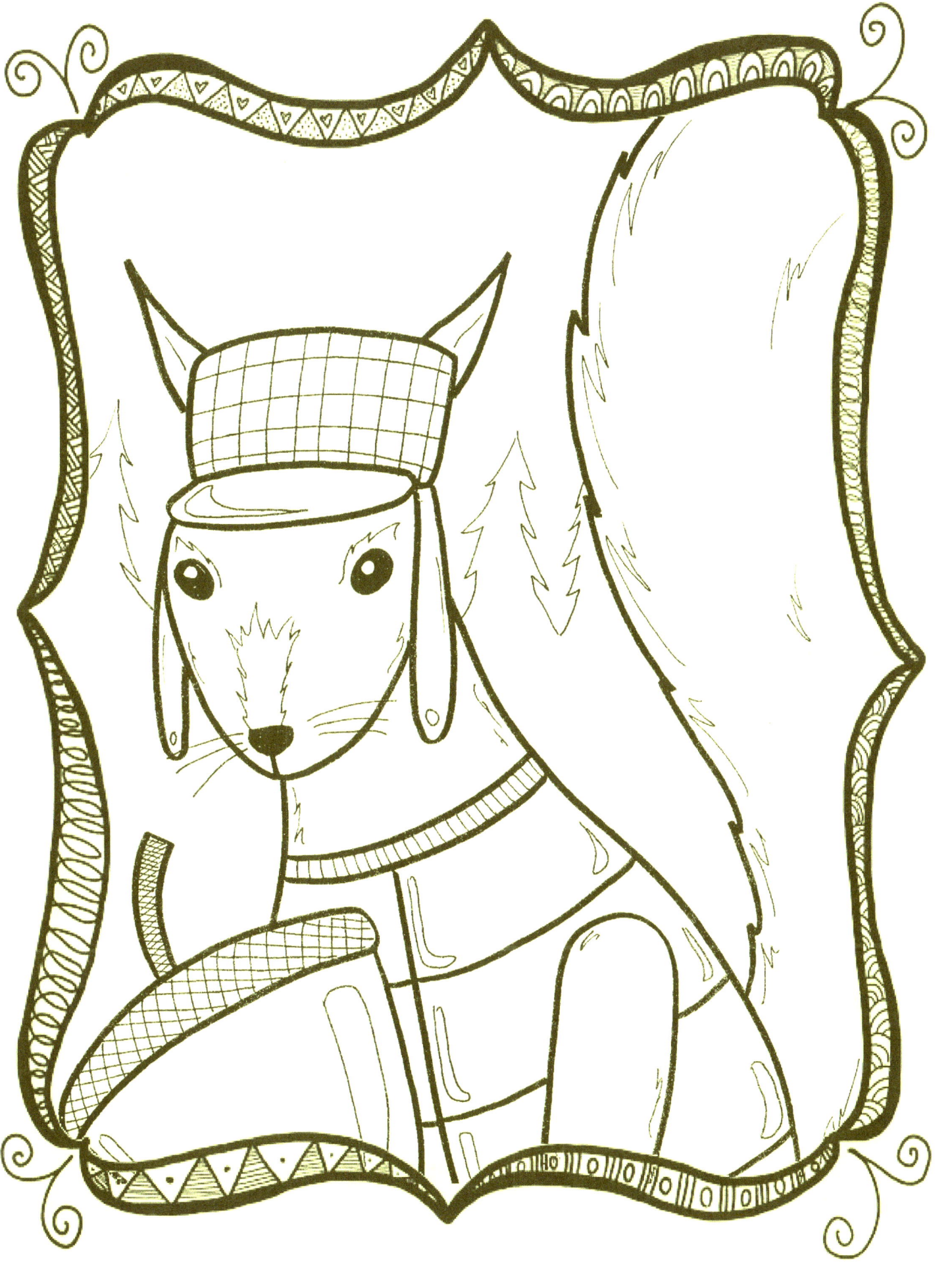

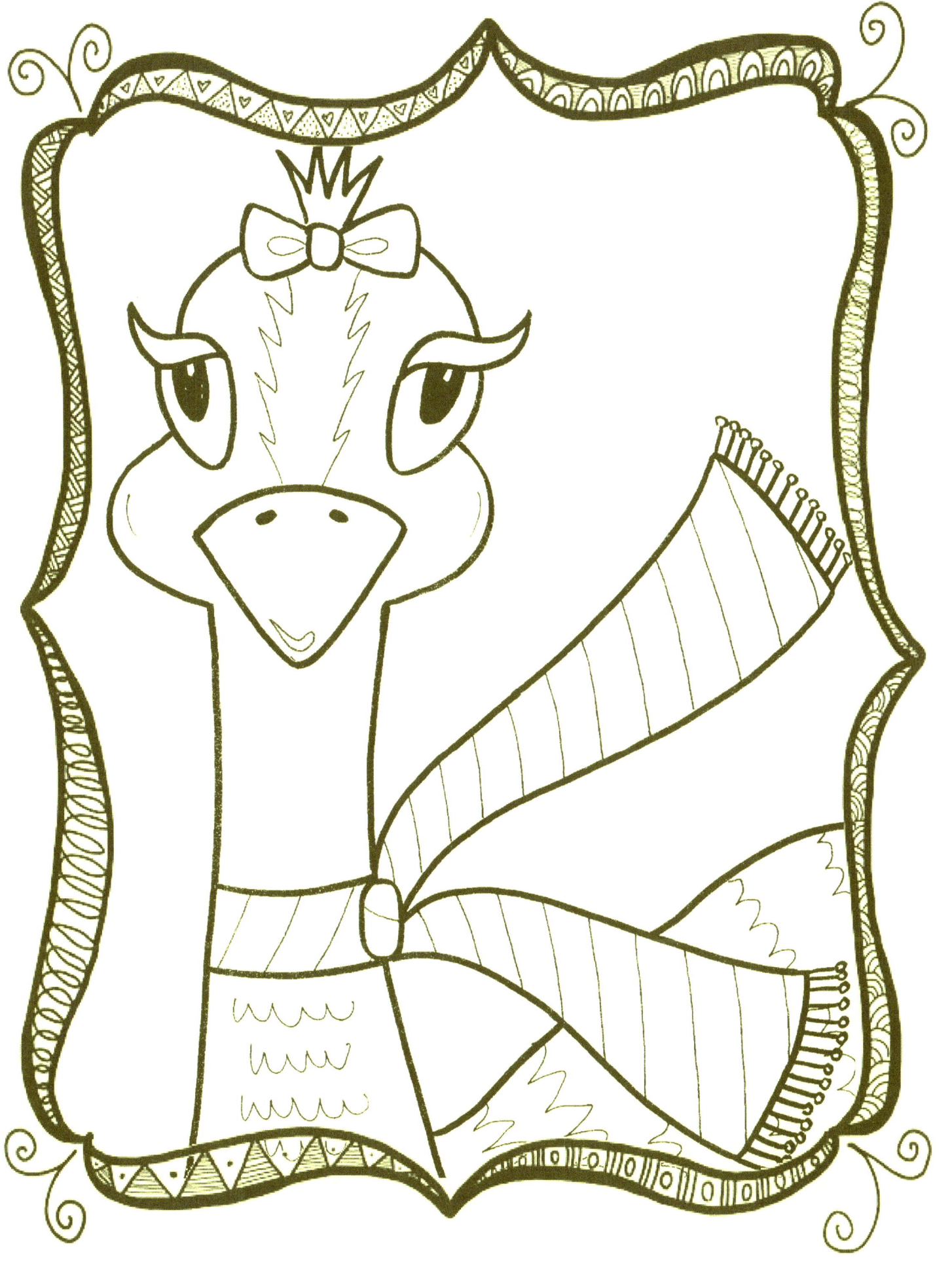

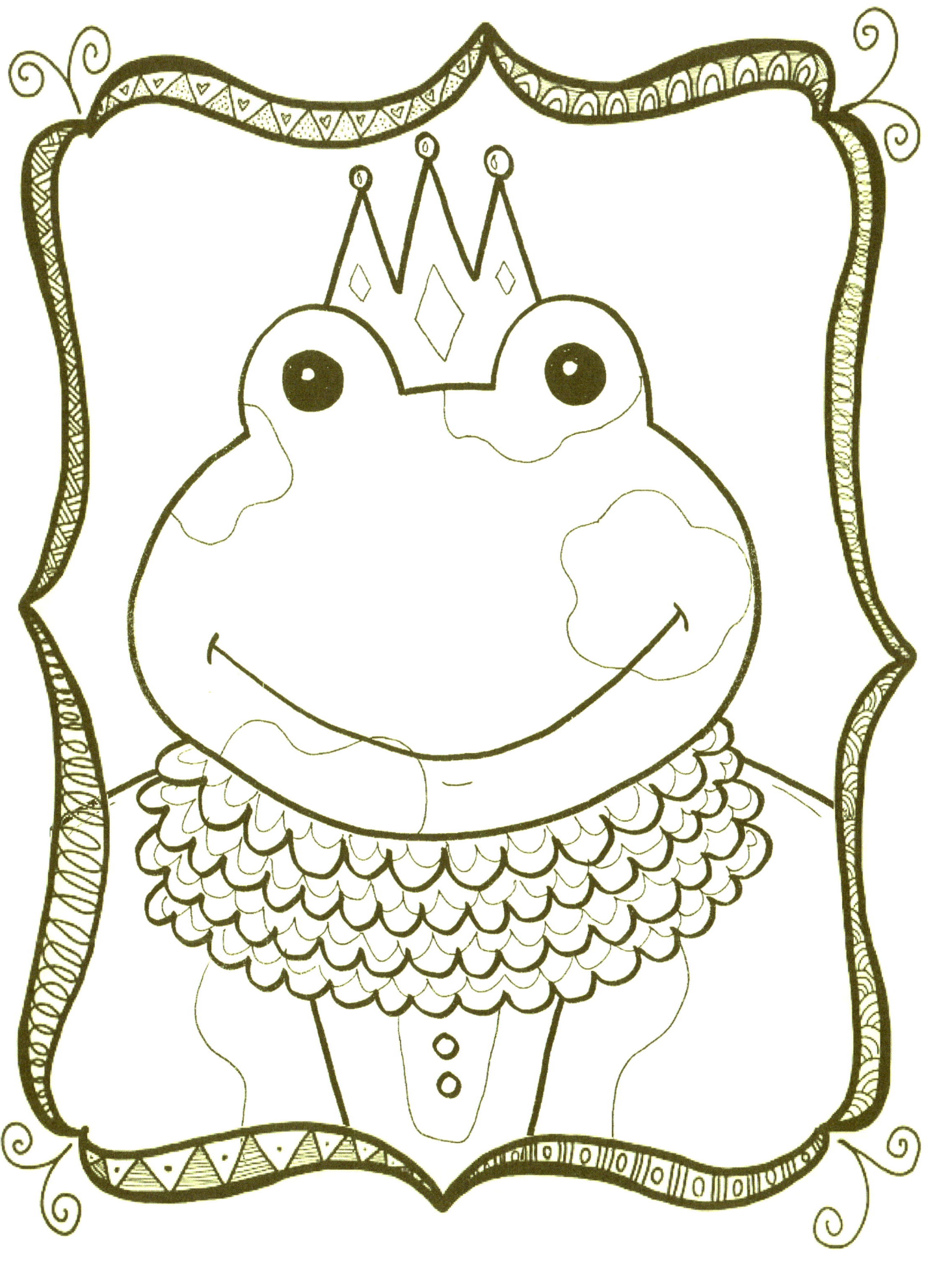

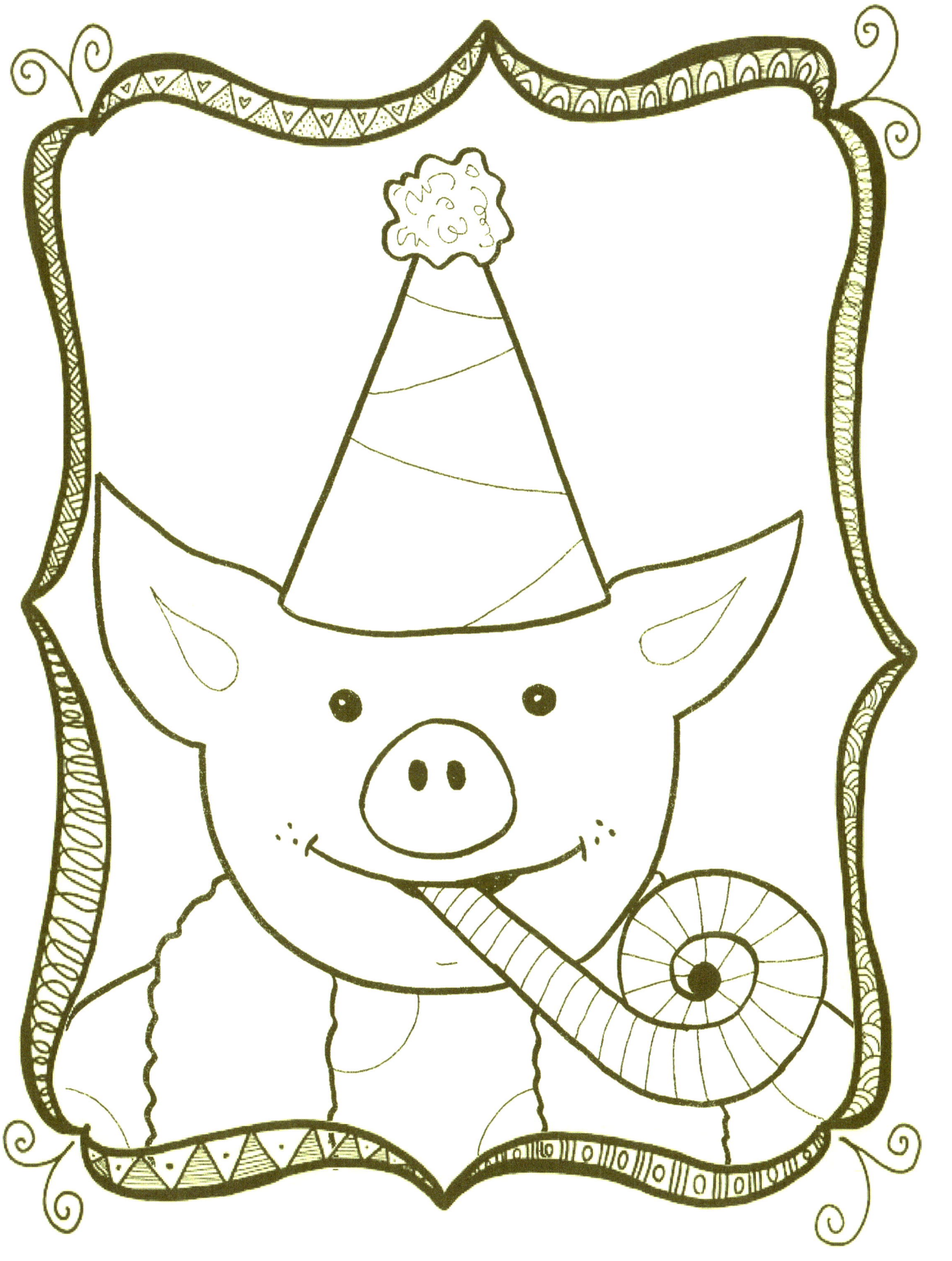

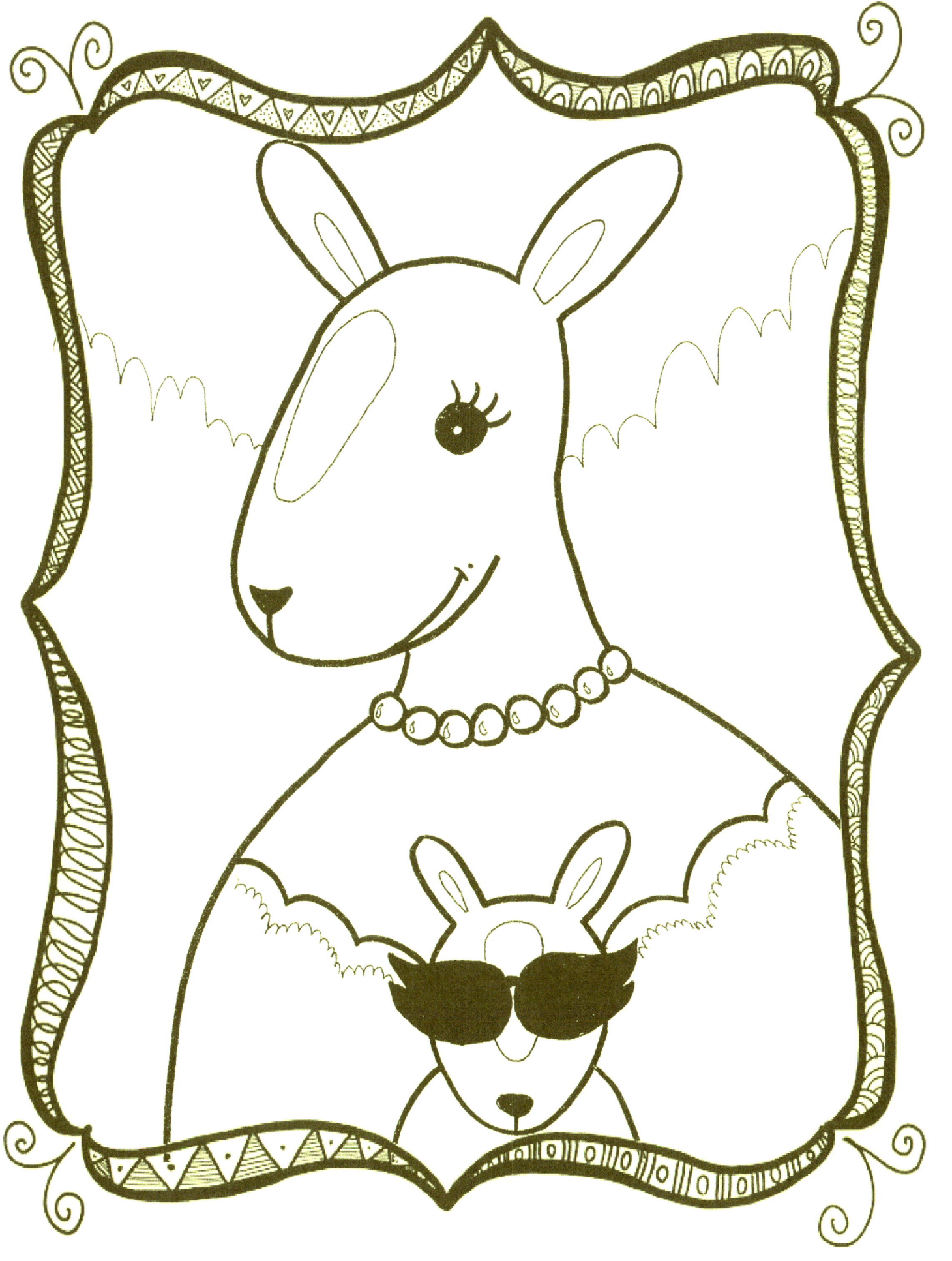

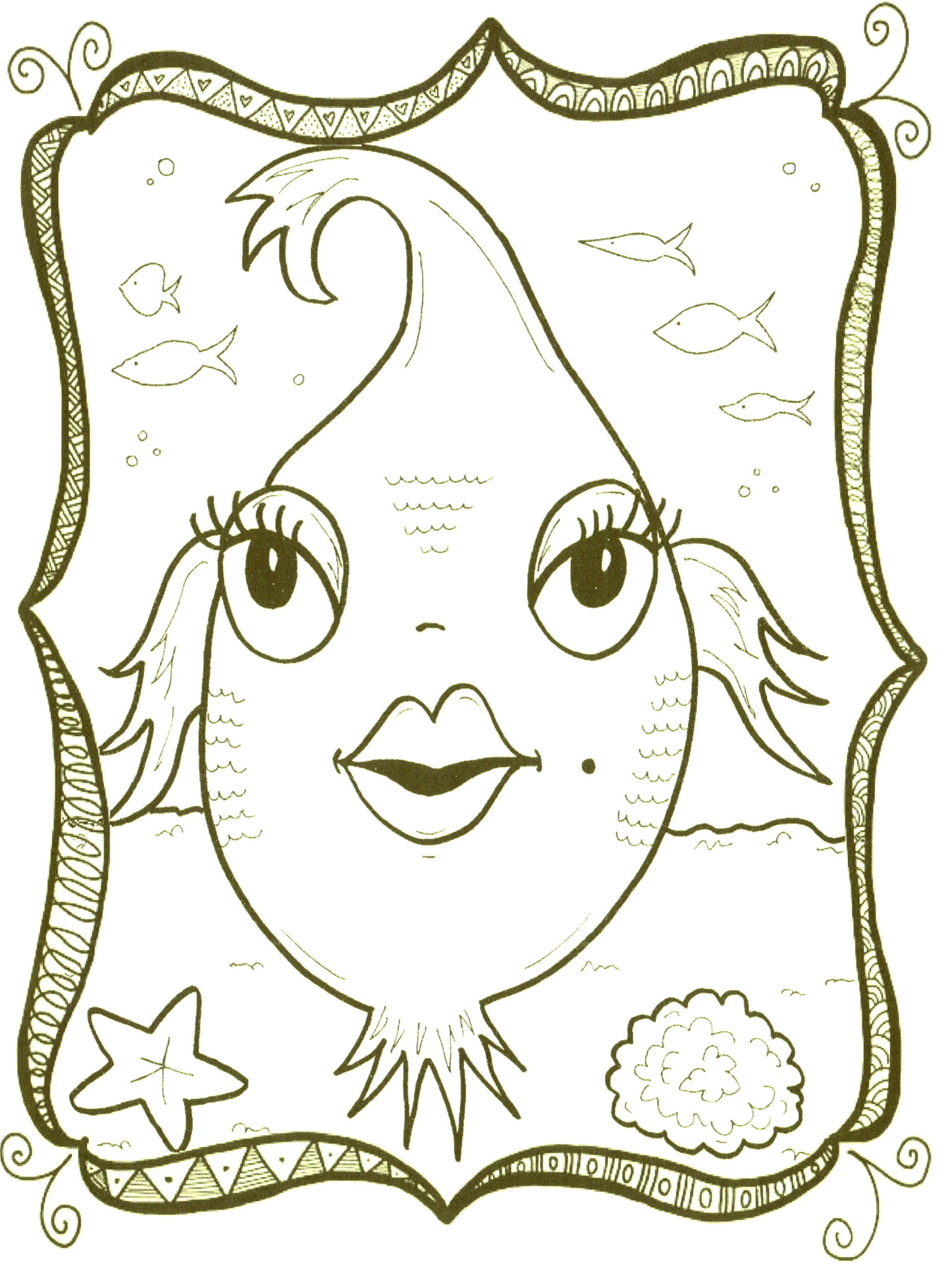

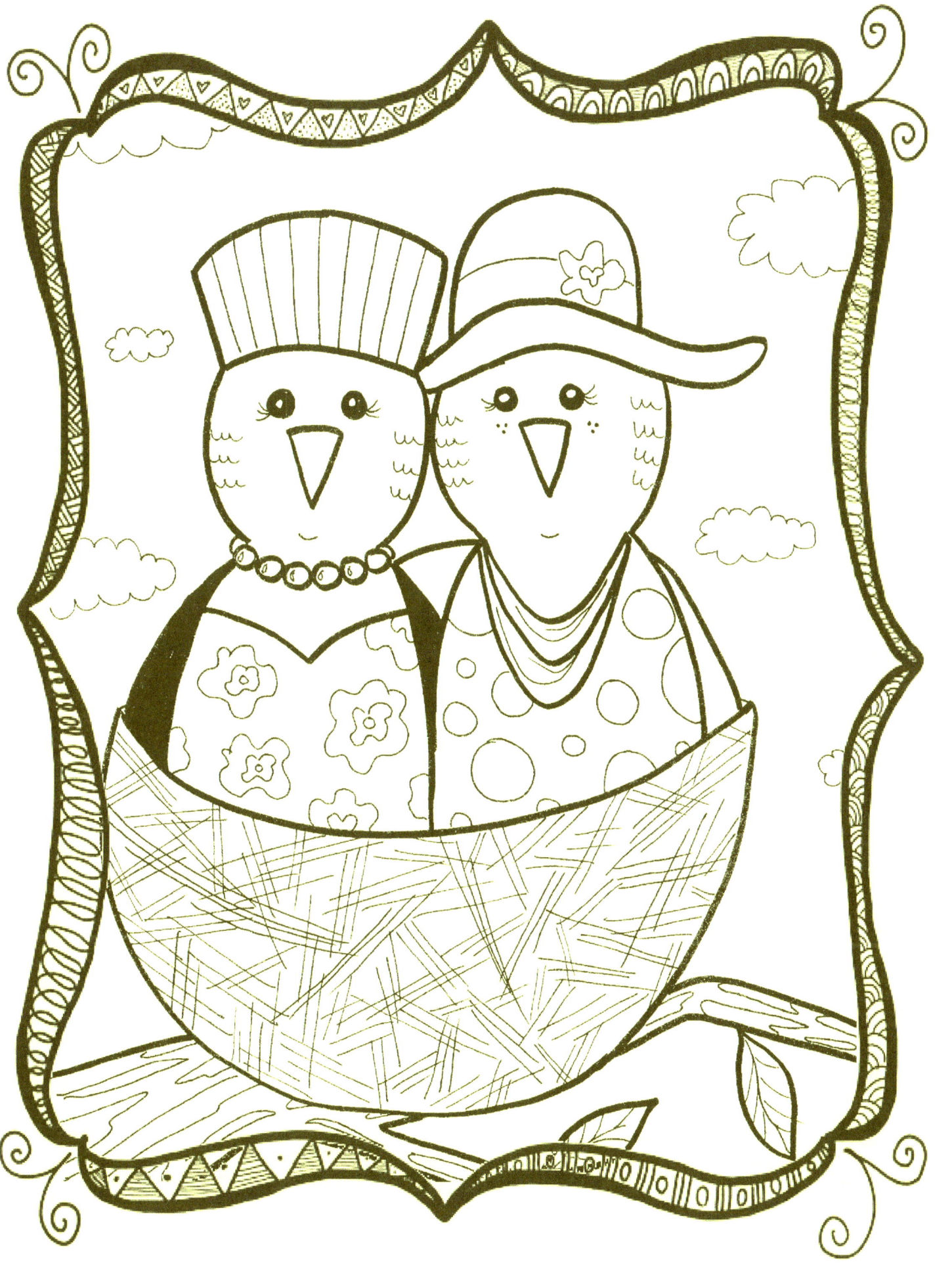

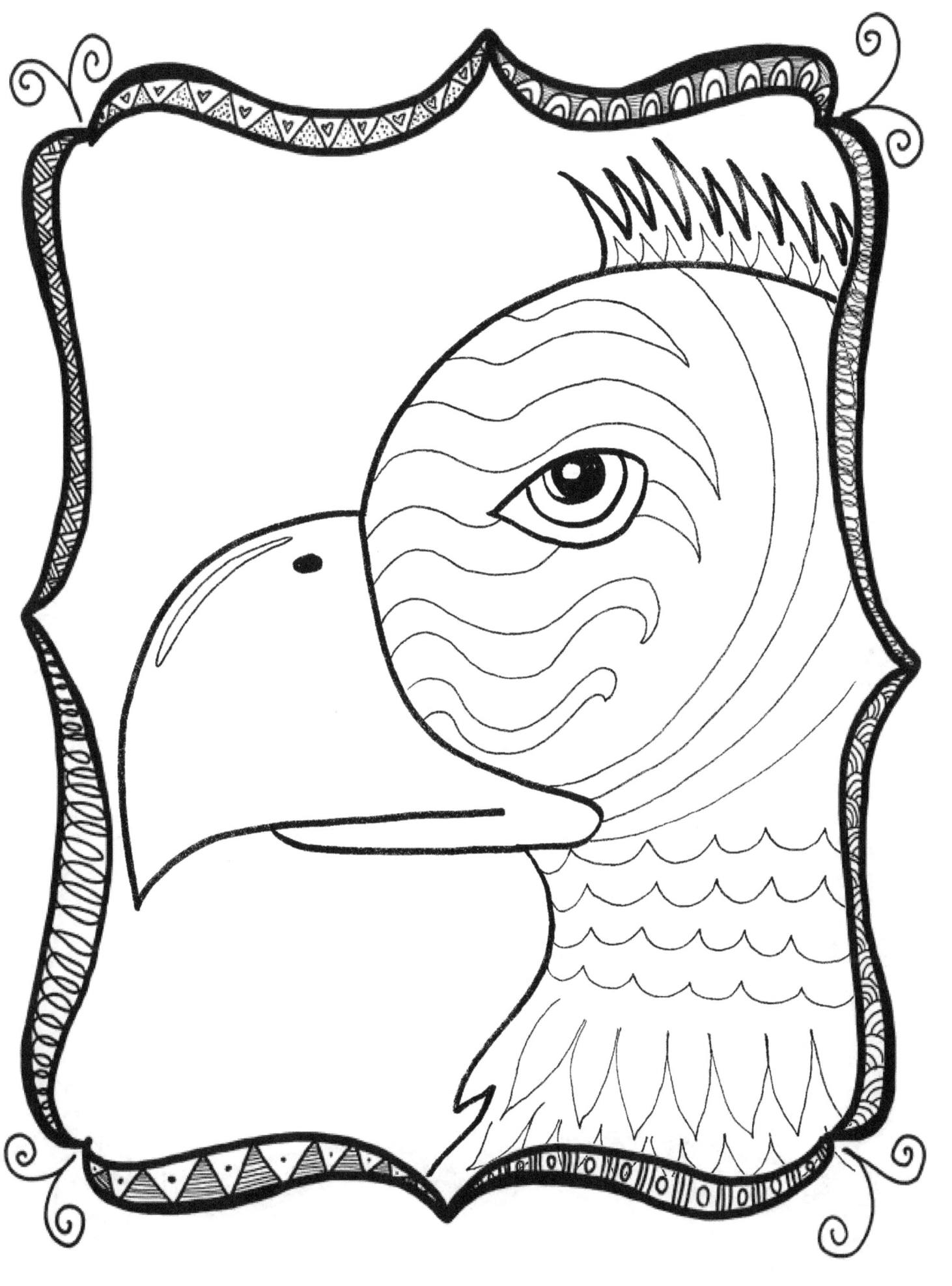

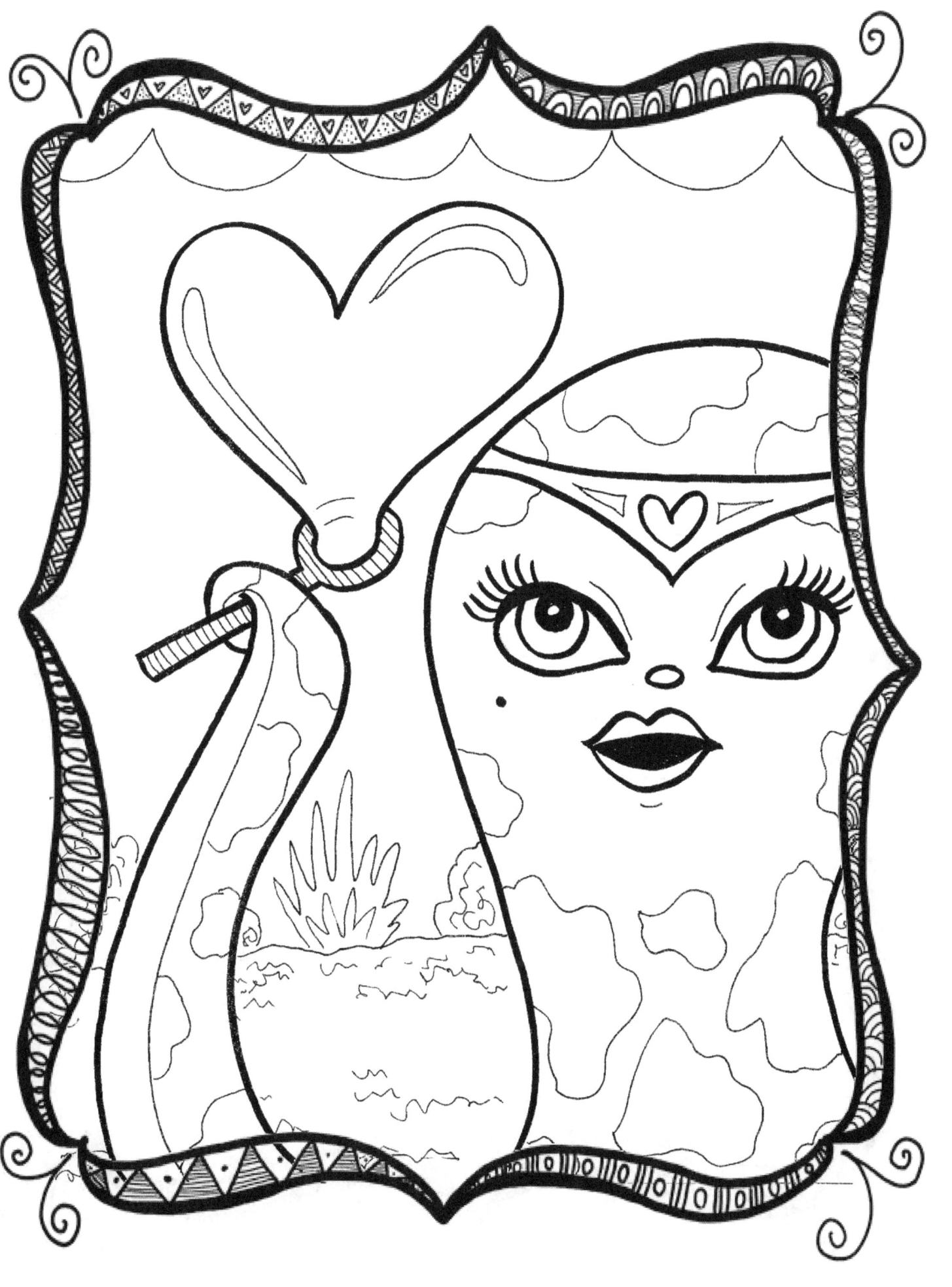

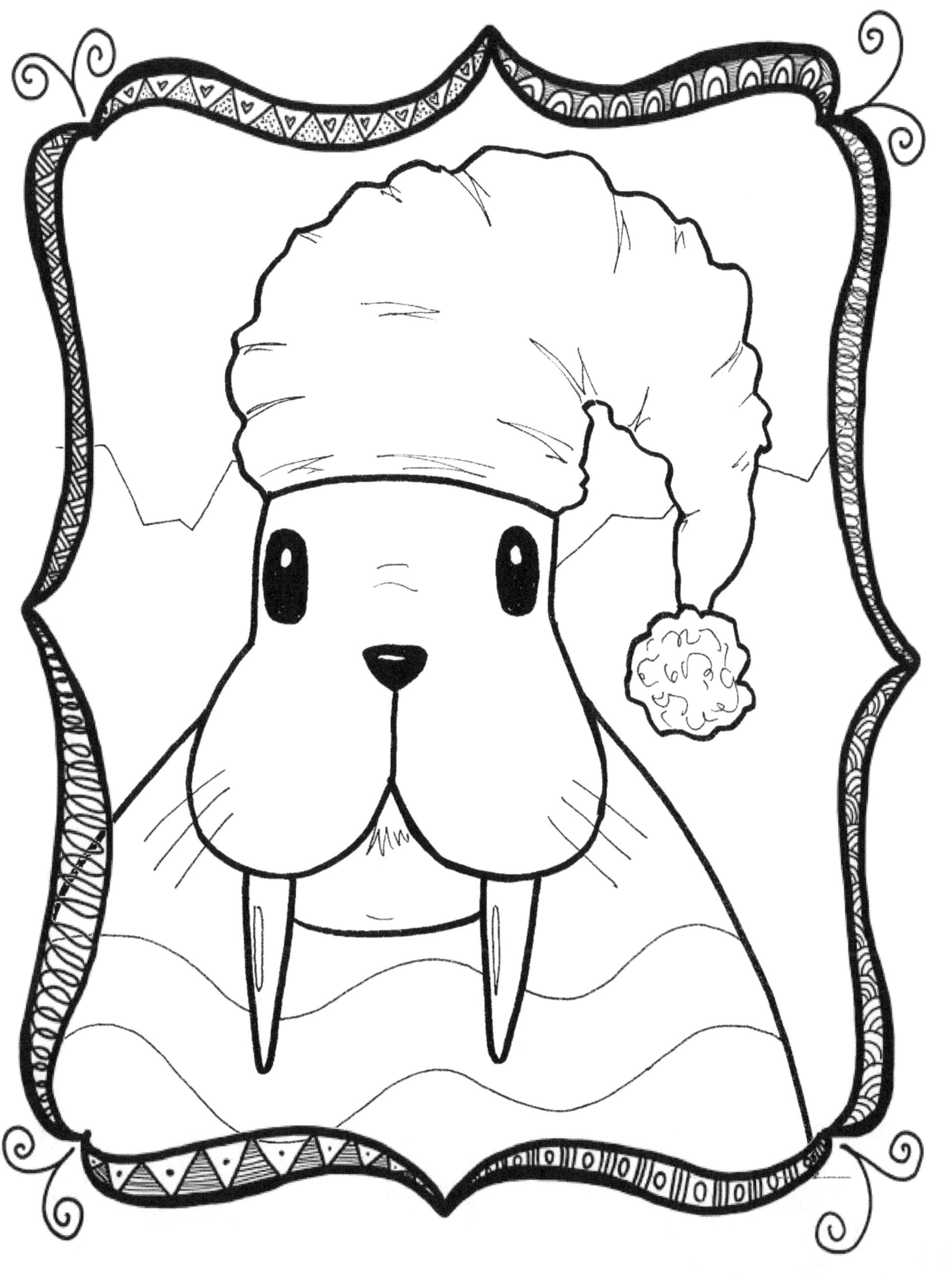

www.ingramcontent.com/pod-product-compliance
Lightning Source LLC
Chambersburg PA
CBHW080723190526
45169CB00006B/2492